CHIHULY *alla* MACCHIA

from the George R. Stroemple Collection

essay by
Robert Hobbs

Art Museum of Southeast Texas
Beaumont, Texas

CHIHULY *alla* MACCHIA Published by the Art Museum of Southeast Texas, Beaumont, Texas

EXHIBITION SCHEDULE

Art Museum of Southeast Texas, Beaumont, Texas
September 4, 1993 – January 9, 1994

Laguna Gloria Art Museum, Austin, Texas
April 23 – June 12, 1994

cover: *Citron Yellow Macchia with Burnt Umber Lip Wrap*, 1982,
10 × 6 × 6 inches

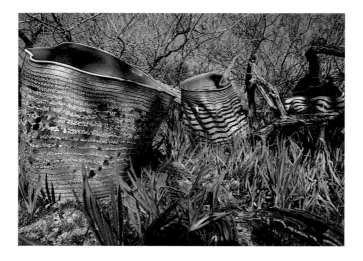

Macchia in the desert, 1982
photograph by Guy Mancuso

Acknowledgments

The glass of Dale Chihuly has been much admired by the public for two decades. His vision, insight, and creativity are evident in each form that comes out of the fires of his studio. Without his extraordinary talent and dedication to the medium, this exhibition would not be possible.

This exuberant review of Dale's "*Macchia*" series would not be on exhibition without the energies, skills, and devotion of two special people, Karen Chambers, Dale's assistant, and Lynn Castle, Museum Curator of Exhibitions and Collections. The resources of Dale's studio were generously opened to the Museum's staff for production of this exhibition.

We appreciate Robert Hobbs' essay for the catalog, Andrée Hymel and Stephen Hallmark's assistance with production and installation of the exhibition. Petra Franklin, Rob Millis, and Heidi Myer of Dale's studio provided invaluable help with the catalog. Diana Johnson's contributions to the editing of the catalog are also greatly appreciated.

The special people who assisted with financial support are essential to any project here at the

Museum. They are Jerry and Sheila Reese, Dan Hallmark and Nancy Neild at Texas Commerce Bank, Dr. and Mrs. Gardiner Bourque, William and Sallye Keith, Ted and Barbara Moor, and Mrs. M.E. Suehs. We are also grateful to George R. Stroemple for lending his collection assembled by his curator, Tracy Savage.

I want to extend a special note of thanks to Carol Barnes and American Airlines who with enormous support enabled the trips to the Boathouse, Dale's studio in Seattle, while the exhibition was being formulated.

Tootsie Crutchfield, President, Tony Chauveaux, President-Elect, and the Board of Trustees of the Art Museum deserve recognition for providing the leadership necessary to bring great art like Chihuly's glass to our small community.

Sheila L. Stewart
Executive Director

Foreword

To understand the work of Chihuly, one should understand the artist. Chihuly is his art. In a room with Chihuly, the atmosphere is electric. This energy is transferred directly to his glass. Valuing labor by hand, the artist combines the talents of many individuals to achieve the most ambitious endeavors. Chihuly directs his team of glass blowers like the conductor of a symphony who continually experiments, explores, and expands his repertoire.

"Chihuly alla *Macchia*" represents twelve years of the artist's energy expended in one series. Chihuly continues to explore variations within the *Macchia*. This exhibit interprets the development of this series.

Robert Hobbs presents a very creative and perceptive essay about Chihuly's *Macchia*. A distinguished art history scholar, Hobbs has contributed extensively to the understanding of many major artists including Lee Krasner, Milton Avery, and Edward Hopper.

Lynn P. Castle
Curator of Exhibitions and Collections

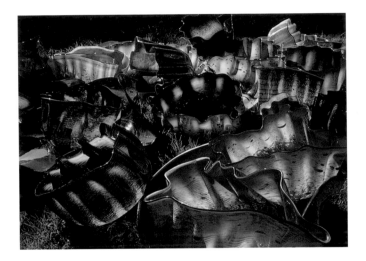

Macchia on the grass at Pilchuck Glass School, 1983
photograph by Edward Claycomb

Macchia

The *"Macchia"* series began with my waking up one day wanting to use all 300 of the colors in the hot shop. I started by making up a color chart with one color for the interior, another color for the exterior, and a contrasting color for the lip wrap, along with various jimmies and dusts of pigment between the gathers of glass. Throughout the blowing process, colors were added, layer upon layer. Each piece was another experiment. When we unloaded the ovens in the morning, there was the rush of seeing something I had never seen before. Like much of my work, the series inspired itself. The unbelievable combinations of color – that was the driving force.

Dale Chihuly

Macchia Drawing (detail), 1993
photograph by Russell Johnson

Derived from the Latin *macula*, the Italian word
"*macchia*" connotes simply a stain or a spot, but it
has a much richer range of meaning. Since the
Renaissance, *macchia* has been associated with a
sketchy way of applying the initial color to a
drawing or painting. Particularly appropriate for the
late style of the Venetian painter Titian, the word
characterizes his emphasis on brushwork and
summary treatment of form. In the seventeenth
century, *macchia* designated the special quality of
improvisational sketches that appear to be nature's
miraculous creation rather than mere human
work. Two centuries later, attention was transferred
from the work of art to its creator; at that time,
macchia signified the initial idea originating in the
mind or eye of the artist that becomes the focus
of a sketch. This later, highly romantic definition
that emphasized the power of artists to reveal nature
through their special sensibilities served as
a basis for the art of the Macchiaioli, the Italian
counterpart to the French Impressionists.

The Italian artist Italo Scanga suggested *macchia* as
the title of the series of work begun in 1981 by Dale
Chihuly. The ability of the word "*macchia*" to
encapsulate the concept of the spontaneous

outpouring of artistic sensibility may have been the reason why Scanga recommended it to his friend. The word choice encompasses more than the mere fact that a distinguishing feature of this series is the artist's preference for splotches of color. When Chihuly appropriates the term *"macchia"* for his series, he gives back to the word some of its traditional meanings, particularly the emphasis on spontaneity, on artistic collaboration with technique rather than mere control of it, and on close kinship between artist and nature. His works with their vibrant dashes of color embody both interpretations of the sketch: the artist's conception and the initial realization of it.

Chihuly and the Creative Act

In conversation, Chihuly repeatedly refers to the mystery and magic of glass. "My work," he concludes, "to this day revolves around a simple set of circumstances: fire, molten glass, human breath, spontaneity, centrifugal force, gravity." All these circumstances accept the immediacy of glass, particularly its tendency to respond to the slightest nuances of pressure created by the glass blower's tools. Coupled with this gestural quality is a direct response to human breath – the only three-dimensional art to do so. Reflecting this

the first American artist/glass blower, rather than designer, to work there. Although his initial experience resulted in a sci-fi prototype for a lamp design, which depended on his immersion in Minimalist/Conceptual ideas and knowledge of contemporary Italian designs, he responded almost a decade later to the challenges of traditional Venetian glass in such series as the "Baskets," "Sea Forms," and "*Macchia*." In his art, Chihuly found modern equivalencies for filigree designs (*latticinio*) and woven glass (*vetro tessuto*). He adapted the Venetian practice of blowing molten glass into molds for his own dynamic purposes, eschewing the symmetry of Muranese production for an asymmetry more indicative of the vicissitudes of the process. The bubble of molten glass is plunged into a metal optical mold, imprinting a "memory" that will be recalled when, in the final moments of forming, the vessel is spun open. The resulting undulating forms can be seen as a critique of the handkerchief shapes that Fulvio Bianconi designed for Venini in the late 1940s. These were, in turn, inspired by the less refined slumped glass vases created by Luigi Fontana for the 1936 triennial design exhibition in Milan. In the *Macchia*, Chihuly makes this former static

élan vital, the *Macchia* at times appear to fulfill the seventeenth-century desire to view spontaneous creation as more the work of nature than the hand of the artist.

This natural quality is heightened in Chihuly's art through its ready acknowledgment of the effects of centrifugal force and gravity during those fleeting moments when the final form of the blown glass is set. These two natural forces acting on blown forms endow the finished pieces with the contradictory qualities of transcendence, which is enacted through the momentary suspension of the molten glass by the centrifugal force of the quickly turning pontil rod, and acquiescence to fate, which is communicated through a yielding of the glass to the forces of gravity.

An American in Venice

Although the Italian word "*macchia*" might appear an affectation for an American artist, Chihuly's experiences working with glass blowers on the island of Murano near Venice preclude such an assessment. In 1968, he received a Fulbright Fellowship to study glass at the Venini Fabbrica, initiating a dialogue with Italian glass that continues to the present. At the Venini factory, he was

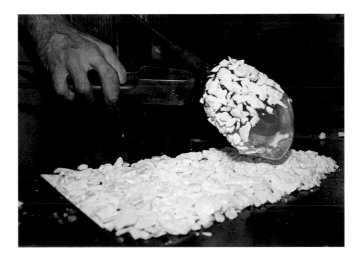

Adding "clouds" to Macchia, 1983
photograph by Mary Laurence

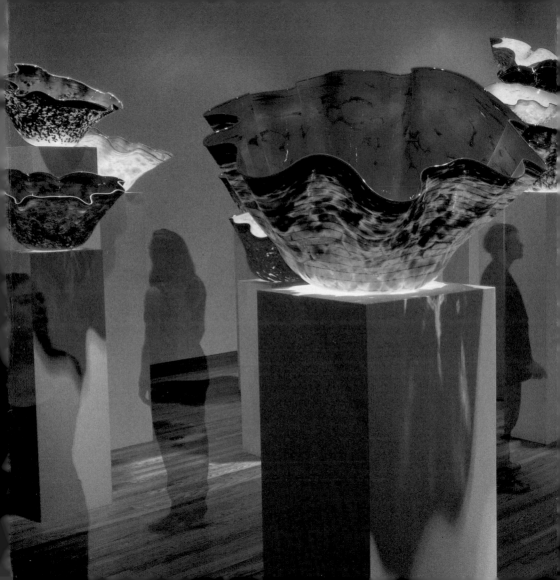

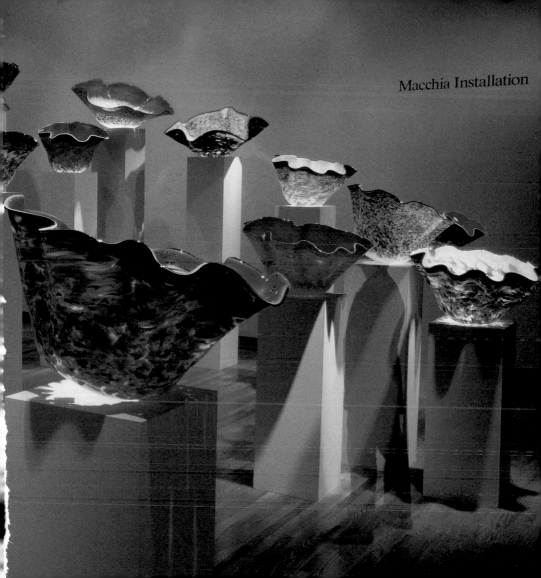

Macchia Installation

Macchia Forest, 1992
photograph by Eduardo Calderon

orientation dynamic and enlarges this conservative scale to awesome proportions. He heightens tensions between inside and outside through dissonant color combinations and through contrasts of opacity, translucency, and transparency. Rather than continuing the preciousness of the filigree of the Bianconi examples, he creates a bolder impact by rolling chips of colored glass into the walls of the vessel for a mottled effect.

Vitalism

Chihuly's *Macchia* perpetuate the vitalist spirit that traditionally begins with the writings of the French philosopher Henri Bergson, who enjoyed great popularity at the turn of the century on both sides of the Atlantic and who deeply impressed such artists as Arthur Dove and Georgia O'Keeffe and later Willem de Kooning and Jackson Pollock. Believing that reality was an ongoing process perceived in immediate experience, Bergson championed intuition over intelligence and instinct over intellect. He believed that reality's flow should not be obstructed by intellectual constructions, and he championed empathy as a way for people to understand their own organic connections with life. Vitalism is particularly evident in the dynamic qualities of Chihuly's

Macchia, which look as if they have only momentarily been frozen in time. Their strong allusions to an ongoing duration connect them with vitalism's flow of life.

This vitalist current in Chihuly's work may be a profound response to the deaths of his brother and father in 1956 and 1957 respectively when Chihuly was still in his teens. These tragic losses may have intensified the life force for him. In Chihuly's work the breath of life is maintained as a central creative force. Glass has become a means for symbolically integrating death with life. The process of glass blowing represents a continuing metamorphosis involving radical changes from molten to frozen liquid states. In a 1986 statement that may be construed both literally as a formalist comment on the work and as a revealing metaphysical or psychological one, Chihuly wrote, "I think that glass has an interior space that's unlike other materials, and I think that probably since 1977, I have been dealing with the interior spaces."

The Dark Side

Similar to dreams, works of art may manifest positive associations that entice both artists and viewers, and they may serve also as necessary

projections of personal and societal fears. This darker side of the *Macchia* is suggested in the term's everyday usage as a spot, stain, blemish, blot. Such expressions as *stampare alla macchia* (to print a pirated edition or to print clandestinely), *alla macchia* (secretly), and *darsi alla macchia* (to take to the woods or to turn highwayman) all allude to the potentially more clandestine side of the "*Macchia*" series.

For Chihuly's *Macchia* this darker side might refer to the fact that the techniques of glassmaking were carefully safeguarded until the twentieth century. In Venice in 1292, the Grand Council decreed that all glasshouses were to be confined to the island of Murano, about an hour's rowing distance from Venice. Ostensibly this was because of the fire hazard of the glass furnaces, but it also meant that the industry could be more effectively nurtured and controlled. Glassmakers were strictly forbidden, on pain of death, to leave Venice or to teach their skills to foreigners.

The secrecy of the craft was stringently maintained until 1962 when Harvey Littleton started teaching glass blowing at the University of Wisconsin. With

Macchia Drawing (detail), 1993
photograph by Russell Johnson

the development of the studio glass movement internationally, through Littleton's efforts and those of his students, including Chihuly, the secrets have been revealed, but the transformation of sand and a few other elements into glass remains seemingly magical. It is particularly apparent in the sense of wonder elicited by Chihuly's glass.

The provisional balance of Chihuly's *Macchia* is a key aesthetic element that reinforces the fragility of glass, its openness to change, and its power as a metaphor of modern life. Although the balance is often precarious, the pieces themselves are never awkward. Looking inevitable, their tentativeness endows them with a strange and alluring force.

Robert Hobbs
The Rhoda Thalhimer Endowed Professor of American Art History, Virginia Commonwealth University

alla MACCHIA

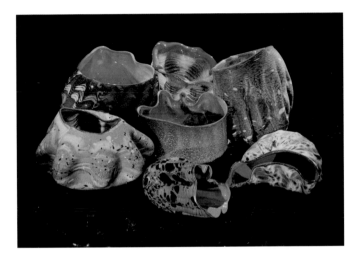

Early *Macchia*, 1981–83

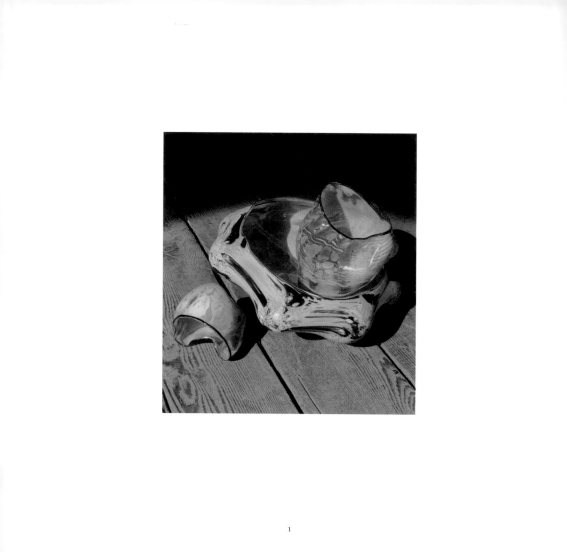

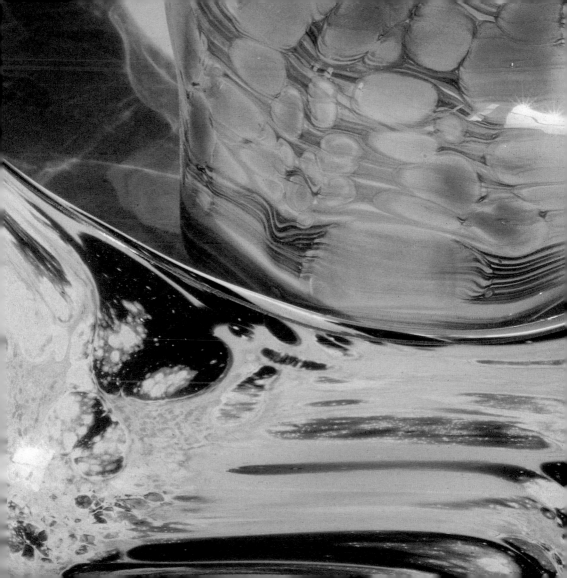

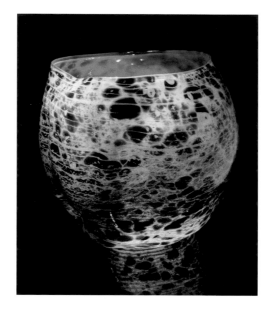

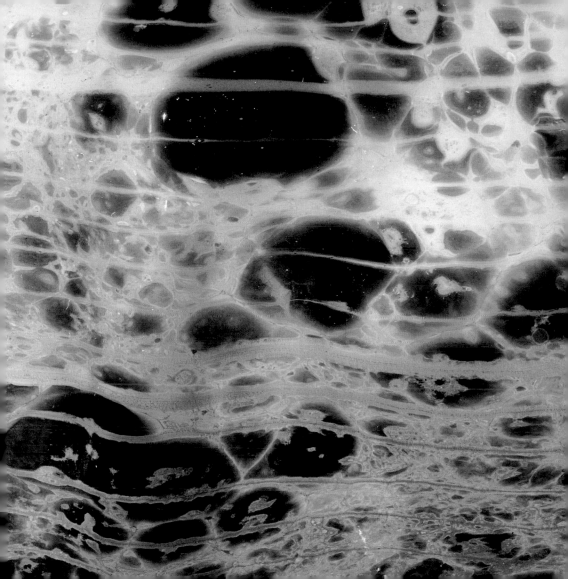

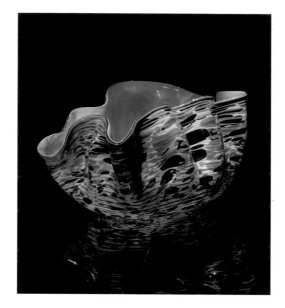

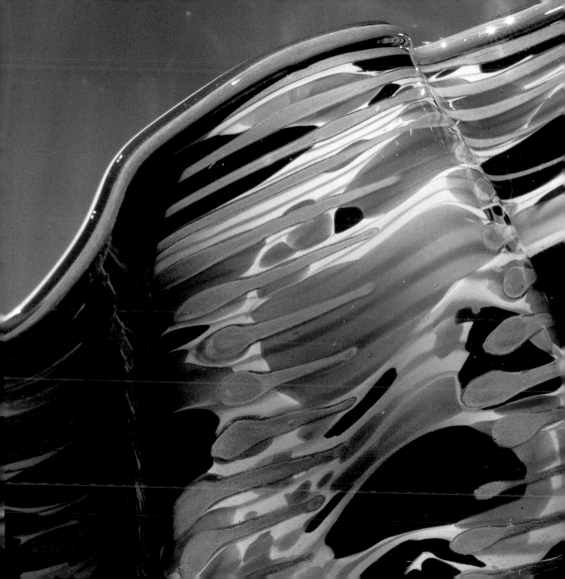

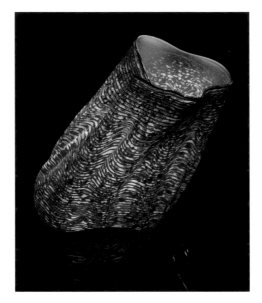

Macchia

In 1964, I took the train from Vancouver to Montreal on my way to Russia. During the sixty-hour ride, I decided I would mix as many colors as I possibly could from a complete set of Winsor Newton watercolors. Three-thousand miles later I had an album filled with thousands of color samples. This was not unlike the thinking behind the "*Macchia*" series. I'm obsessed with color – never saw one I didn't like.

Dale Chihuly

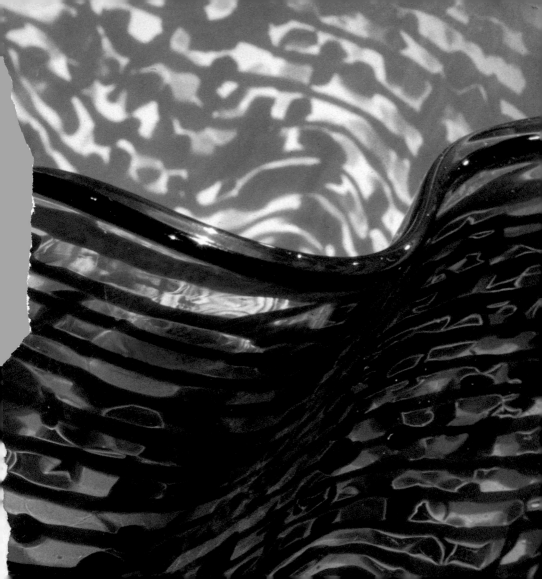

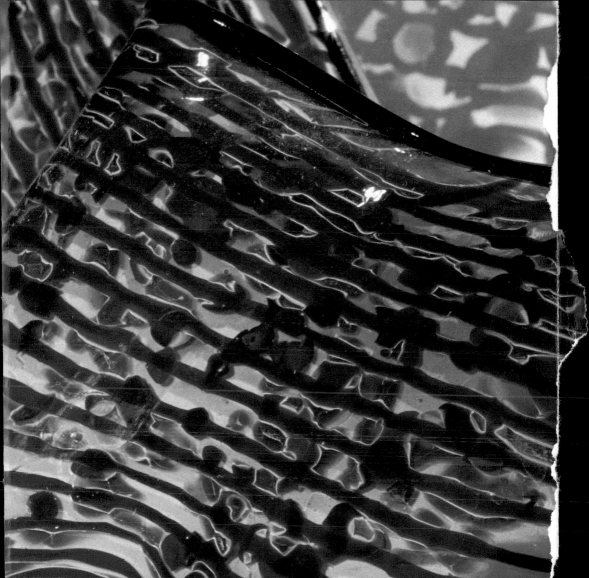

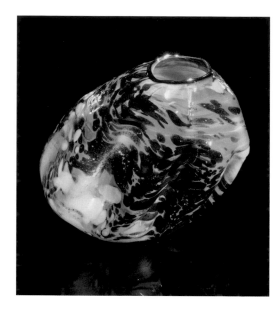

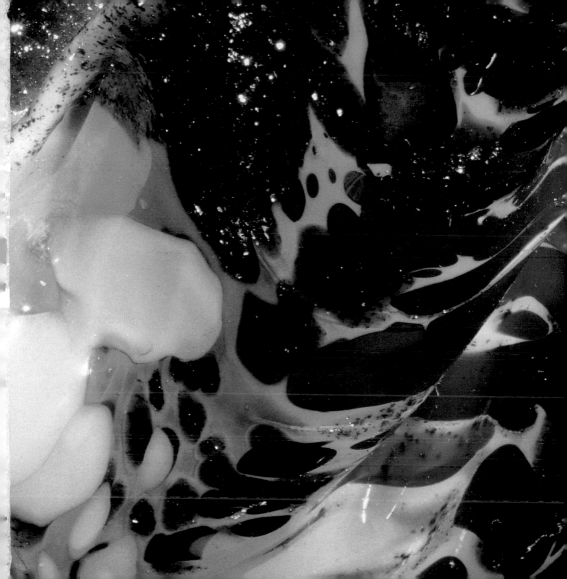

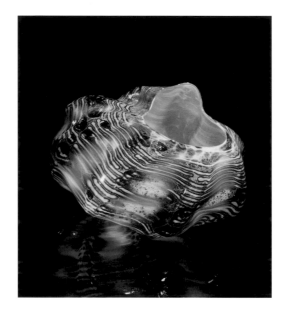

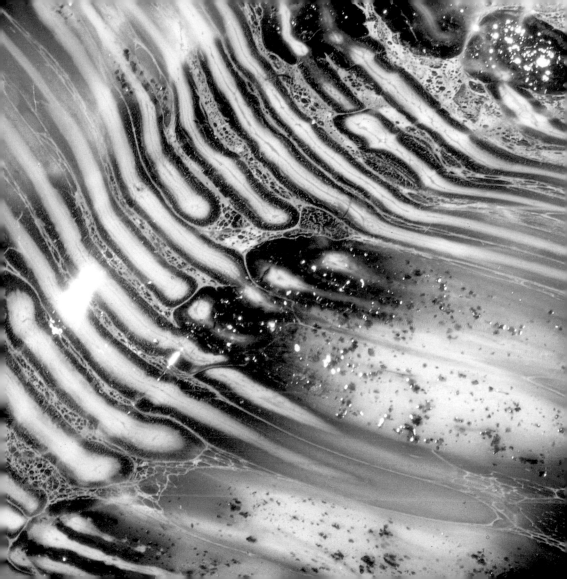

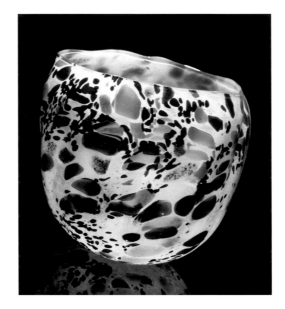

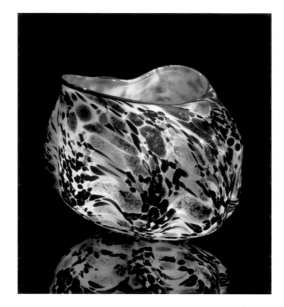

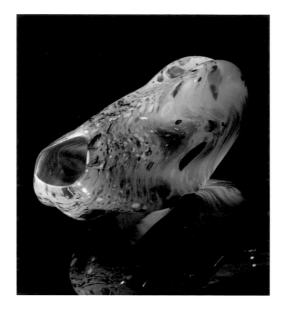

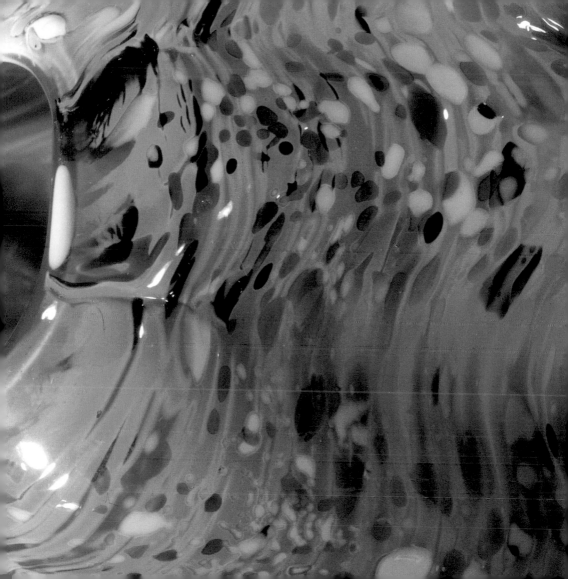

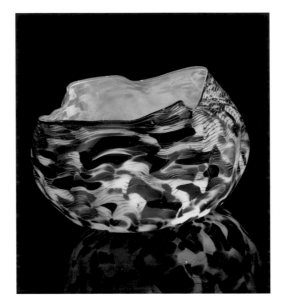

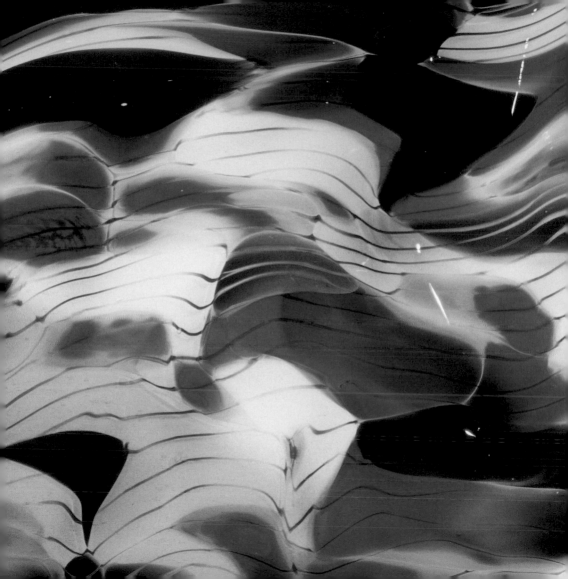

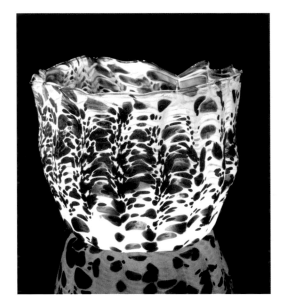

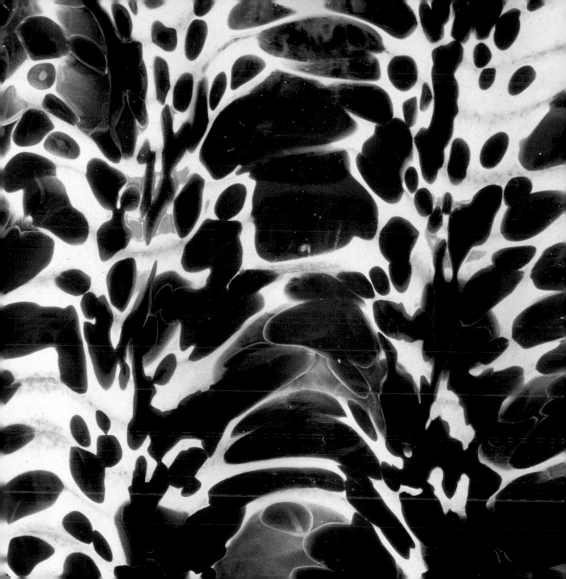

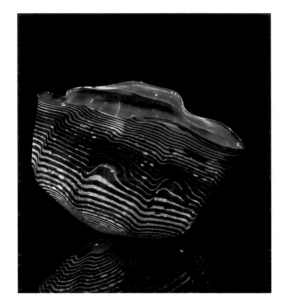

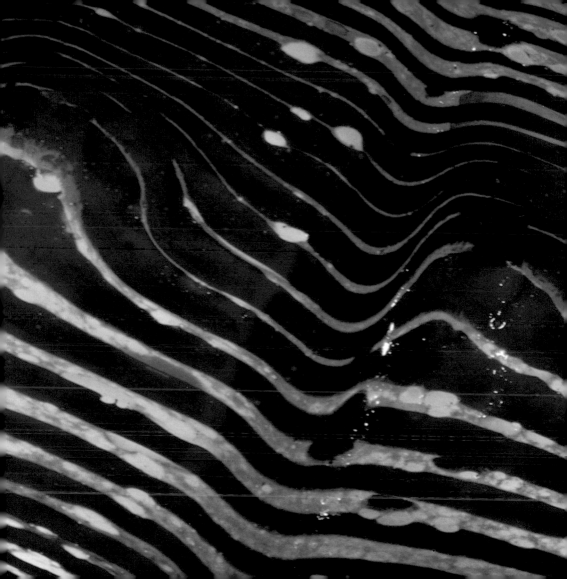

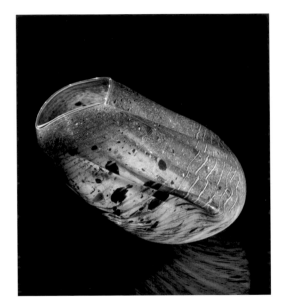

Macchia

When my mother first saw the *Macchia,* she called them the "uglies" because the colors were so bizarre. When it came time for the exhibit, I didn't know what to call the series. I phoned my best friend, Italo Scanga, and asked him what "spotted" was in Italian. He had forgotten, having lived in the United States so long, but he looked it up and then called me back and said, "*Macchia.*"

Dale Chihuly

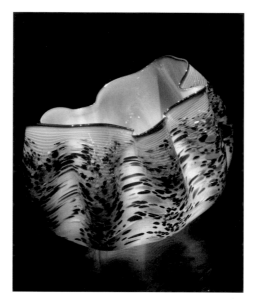

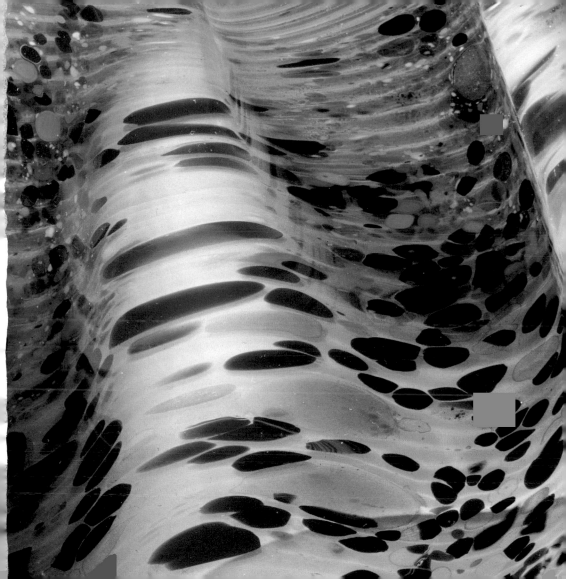

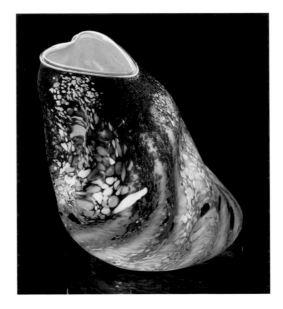

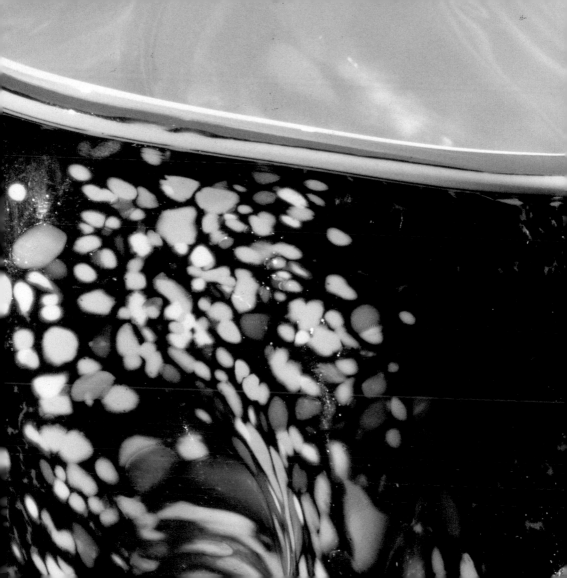

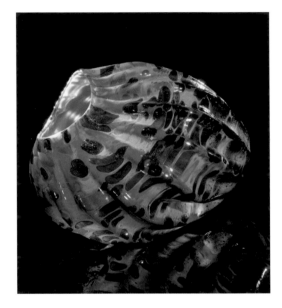

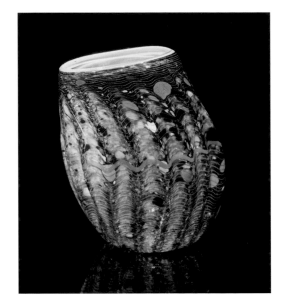

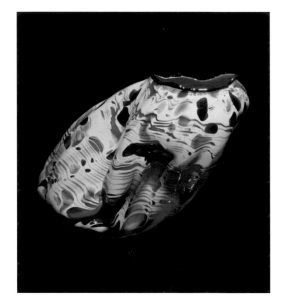

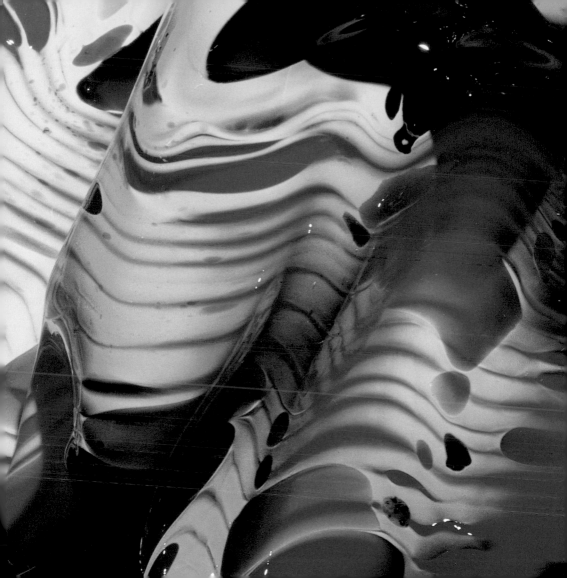

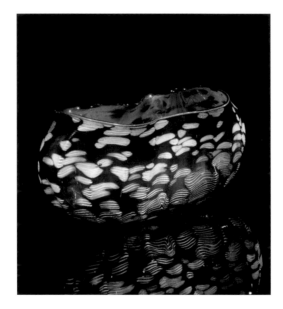

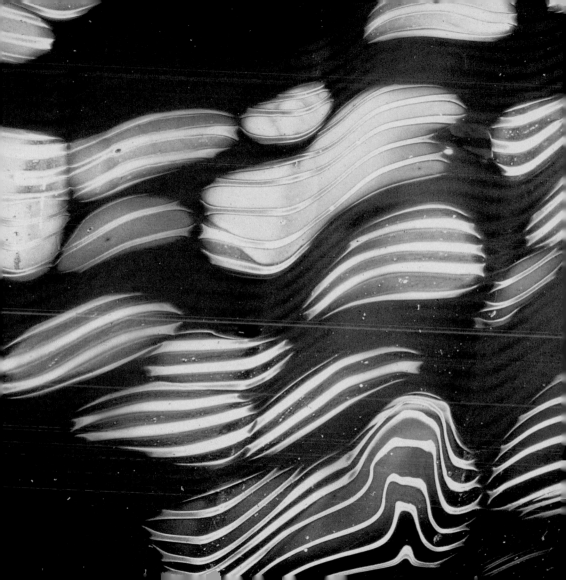

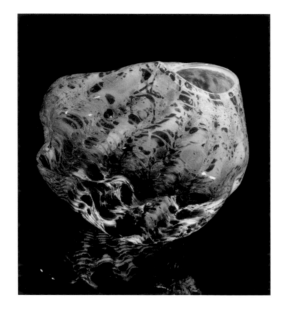

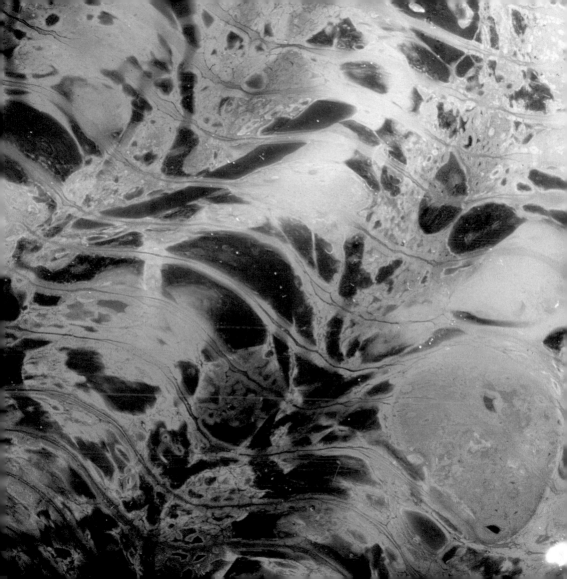

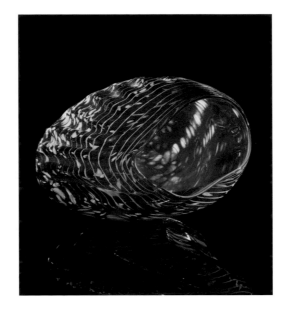

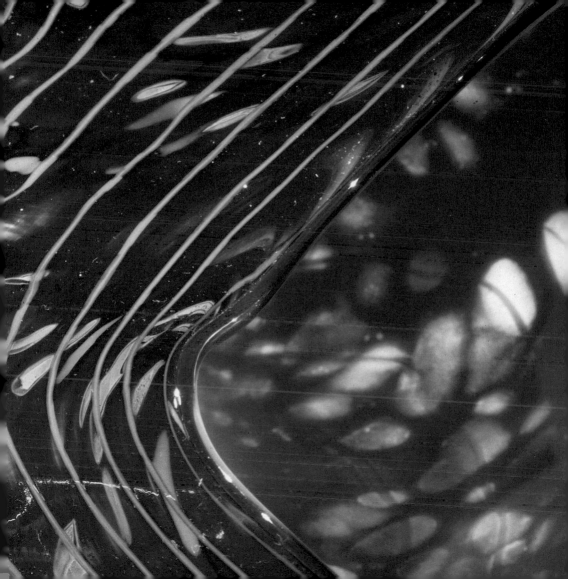

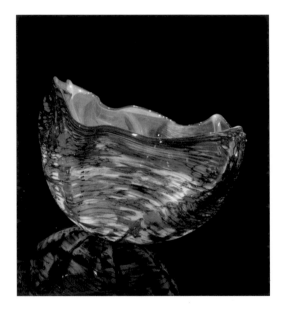

Macchia

I remember studying a beautiful stained glass window. Part of the window was in front of a white building, the other half was backed by the blue sky. The blue sky really killed the delicate tints in the window. It had the same effect as if one were wearing blue glasses. That's when I learned the importance of white. While blowing the early *Macchia* I added a layer of "clouds" between the inside and the outside colors. It was the white that allowed the colors to pop. I could now have one color on the interior and one on the exterior without any blending of the colors.

Dale Chihuly

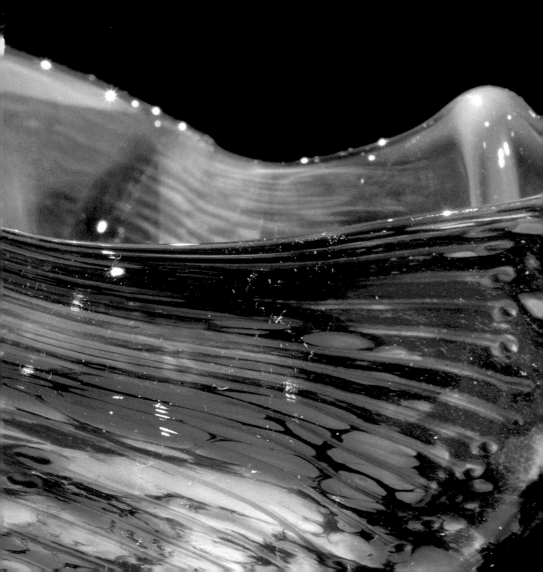

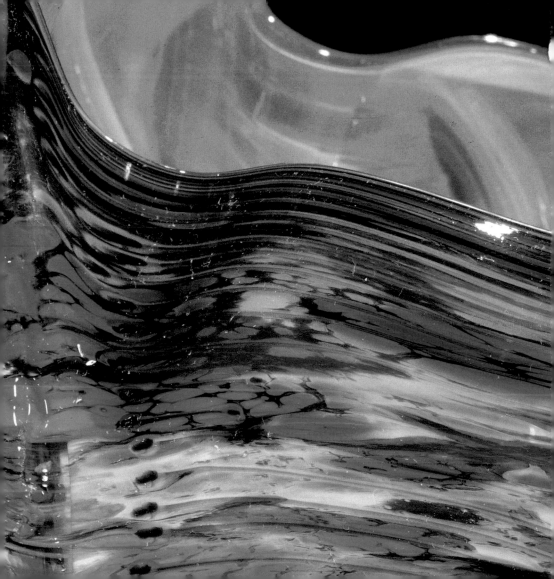

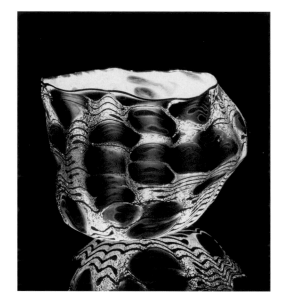

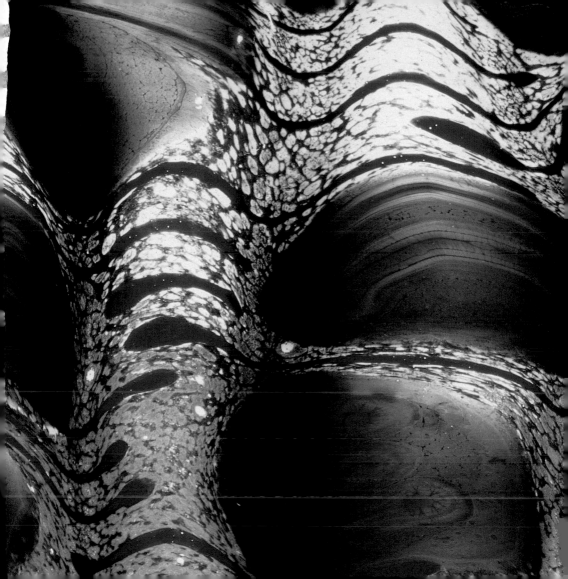

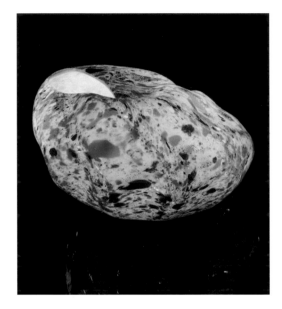

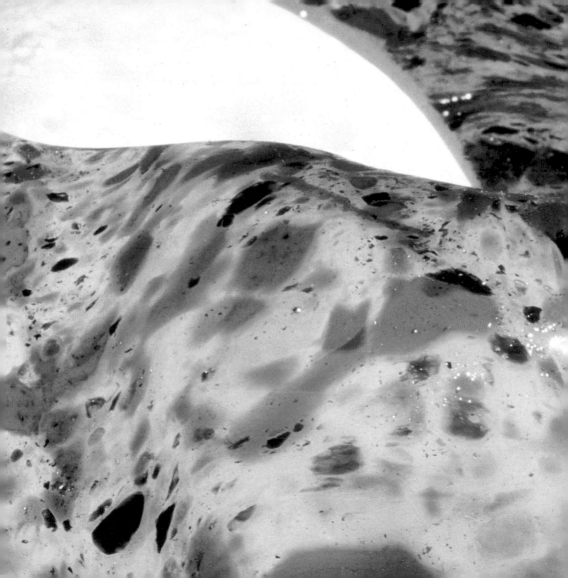

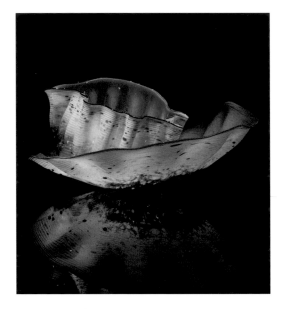

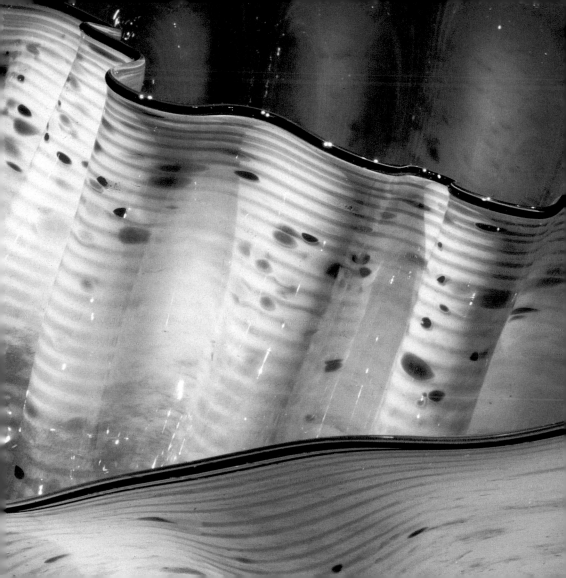

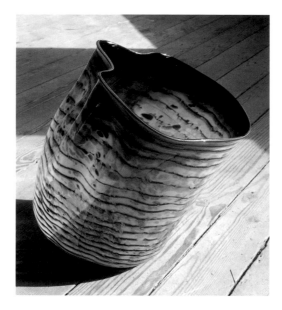

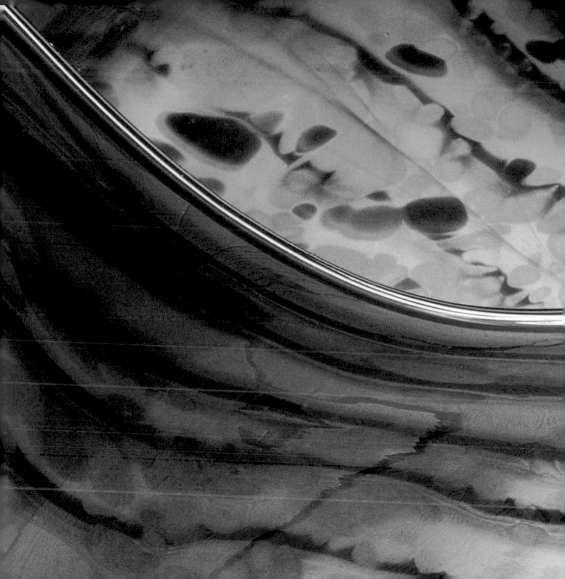

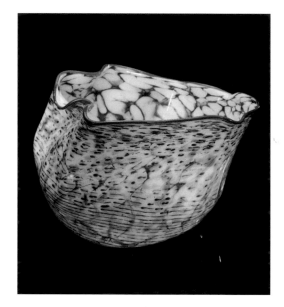

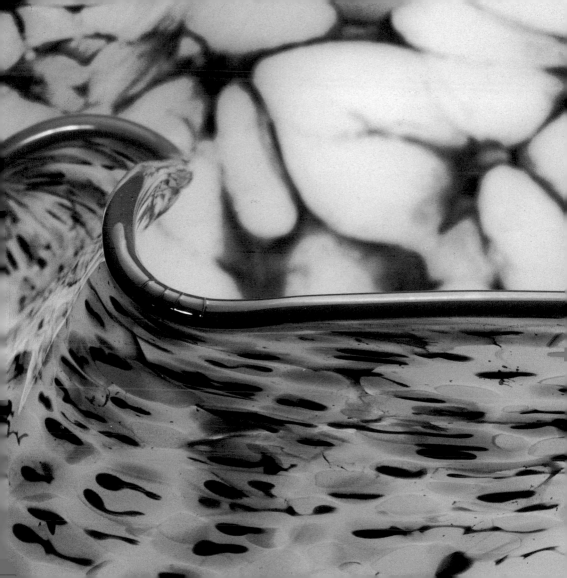

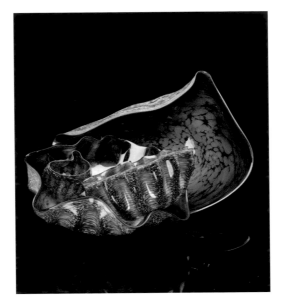

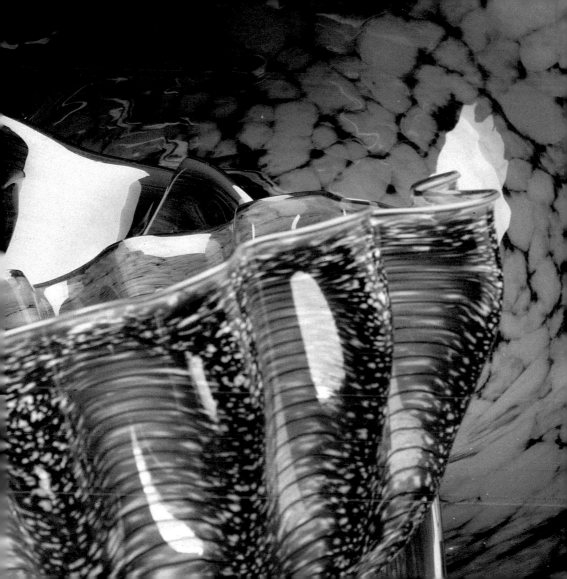

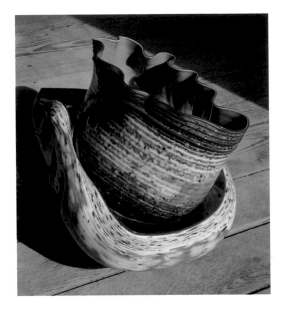

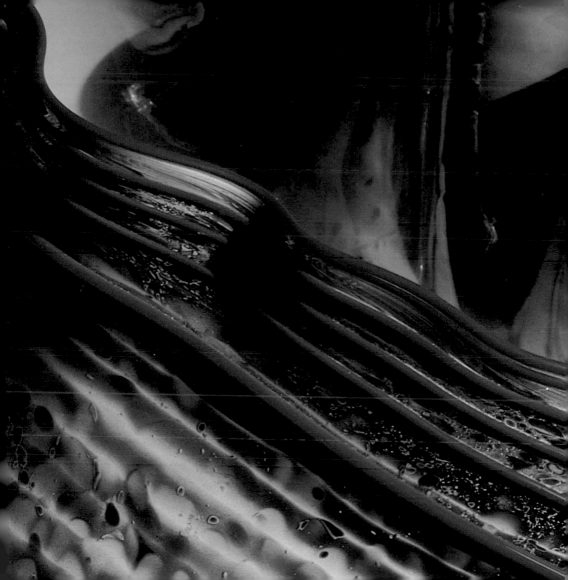

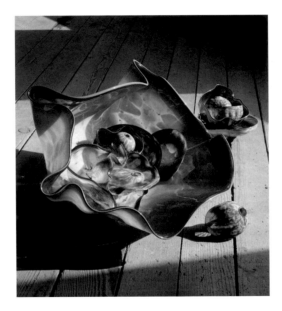

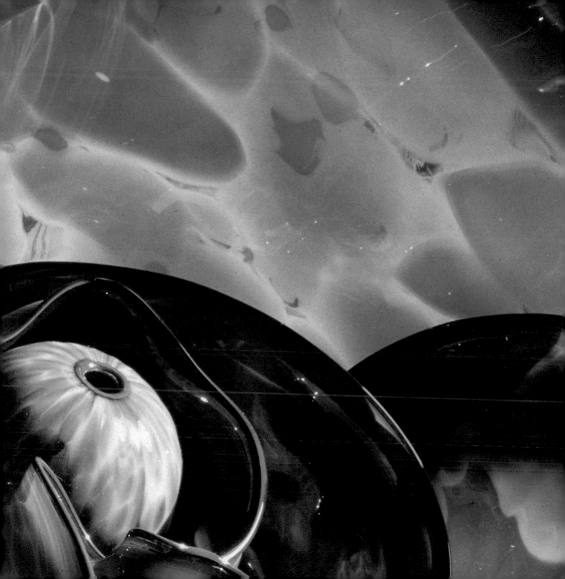

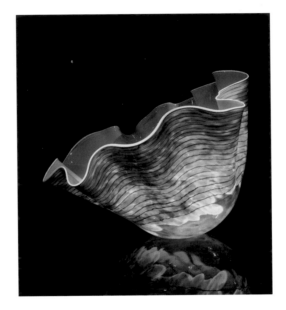

Macchia

Most people don't realize it, but blowing a piece with a range of colors is extremely difficult because each color attracts and retains the heat differently. Over time we figured out these technical complexities and the *Macchia* began to increase in size. Eventually the pieces got up to four feet in diameter and with them I felt for the first time that a single piece of my glass could hold its own in a room.

Dale Chihuly

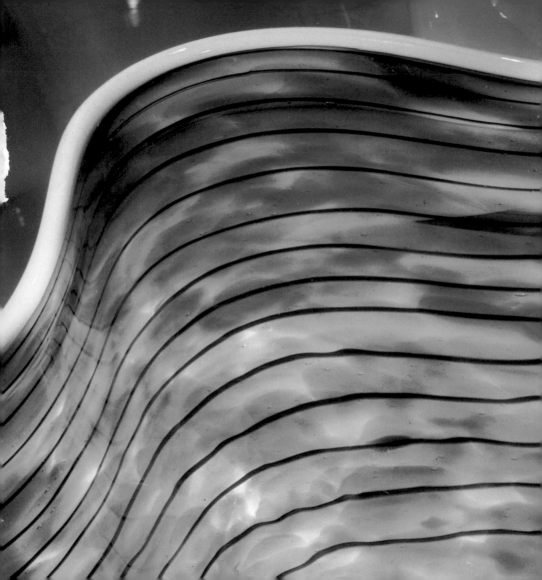

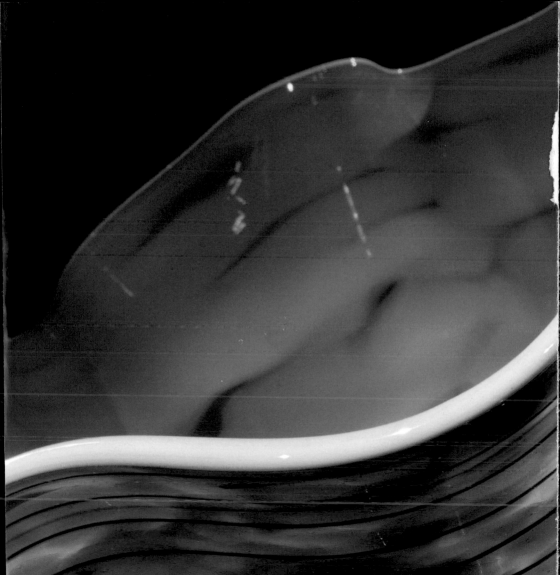

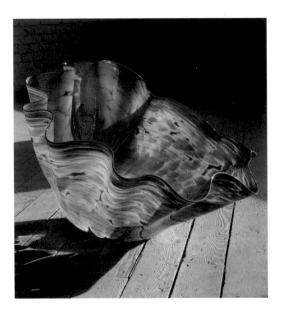

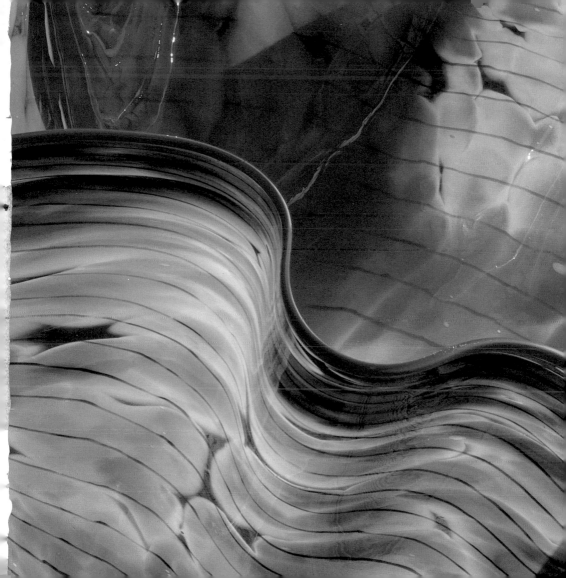

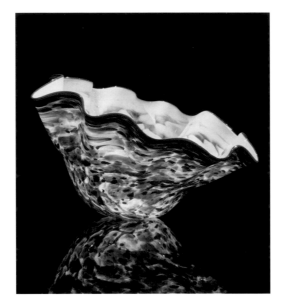

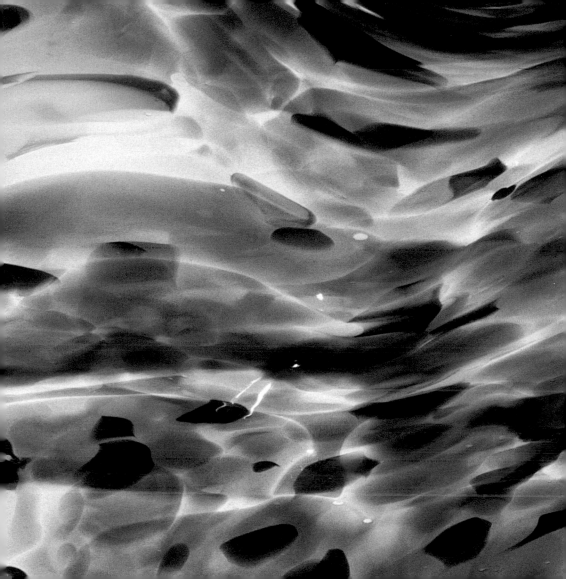

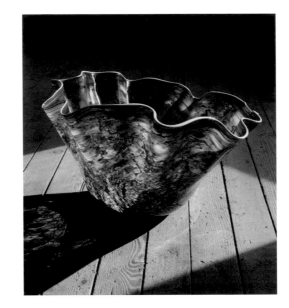

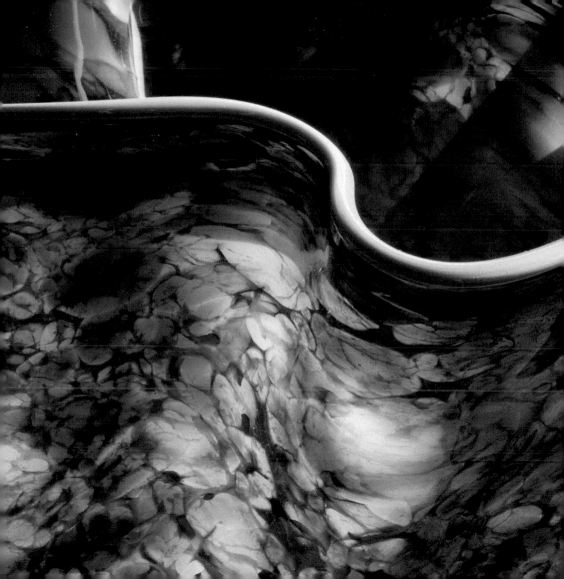

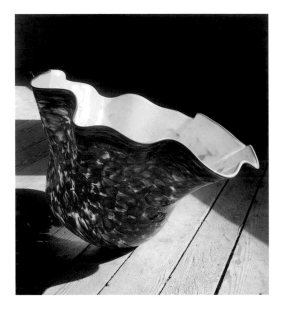

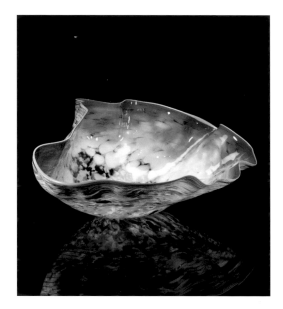

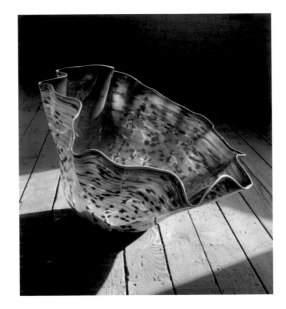

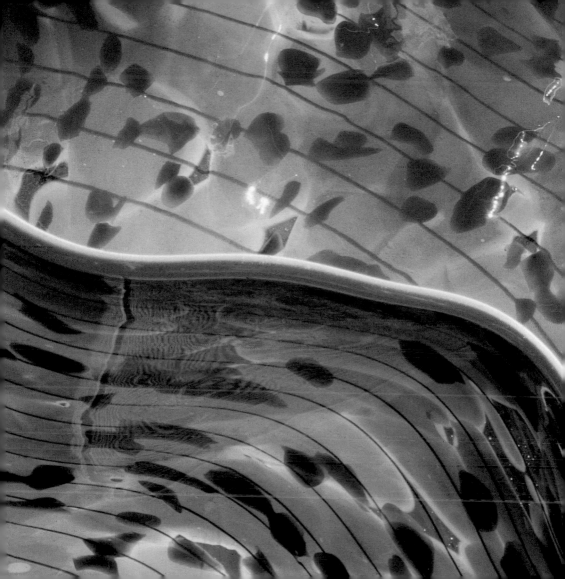

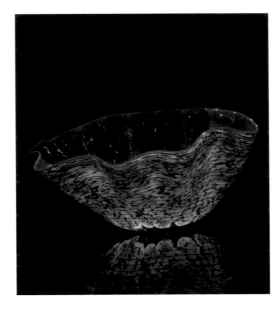

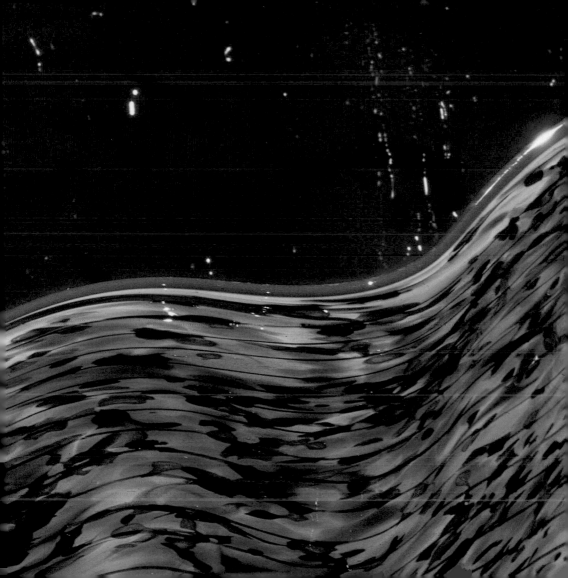

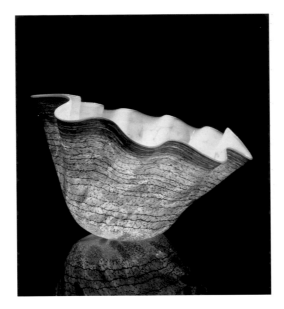

alla MACCHIA

on paper

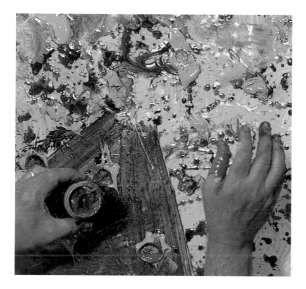

detail of *Macchia drawing,* 1991
photograph by Russell Johnson

inside spread: Chihuly at the Boathouse, 1993
photograph by Russell Johnson

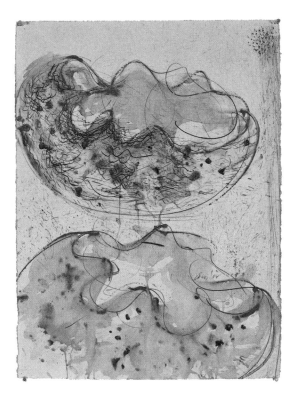

40

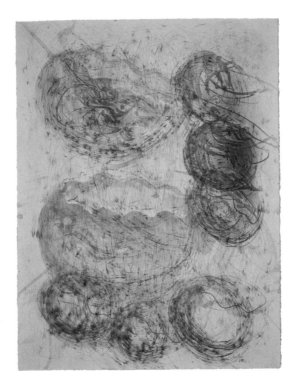

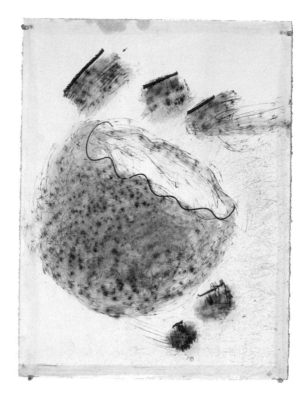

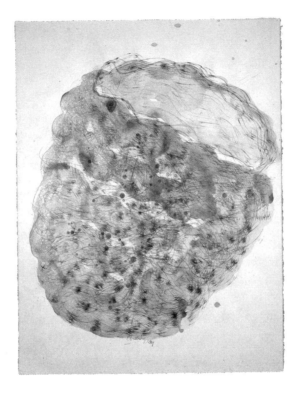

43

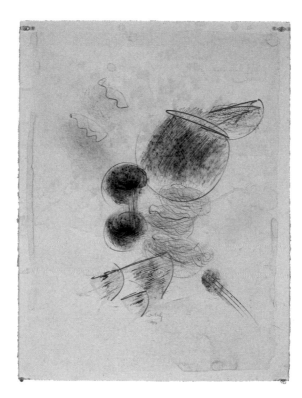

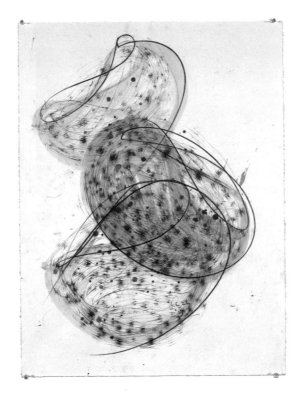

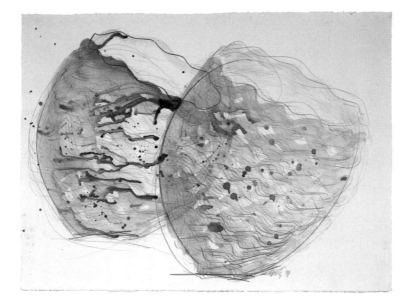

46

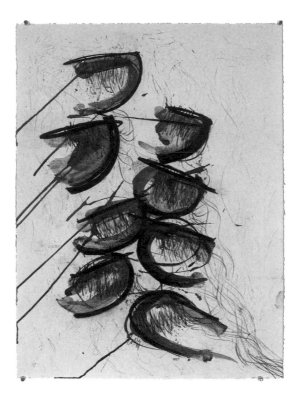

47

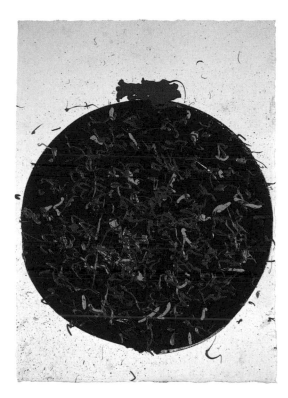

48

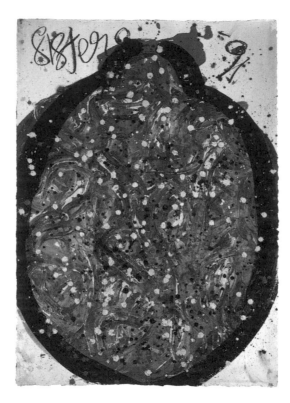

49

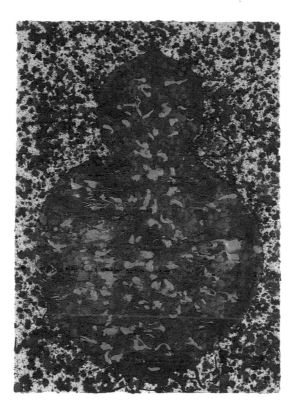

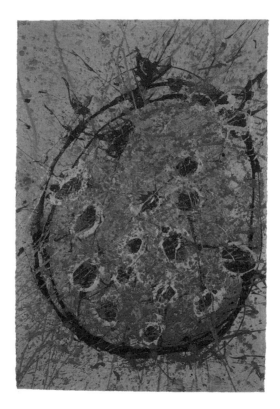

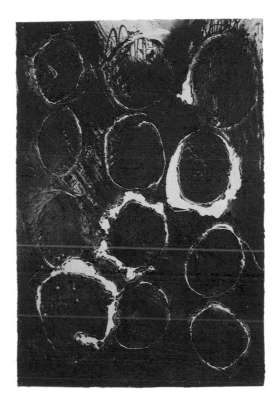

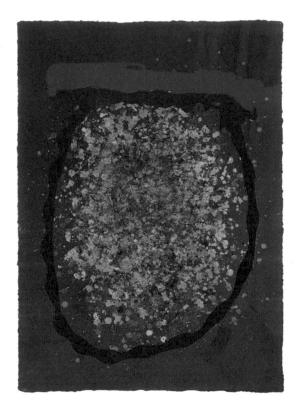

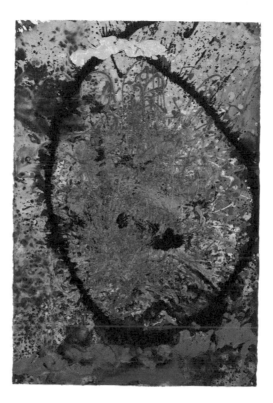

Exhibition Checklist

1 *Payne's Gray and Oyster Macchia Set,* 1982,
7 × 12 × 10 inches

2 *Veronese Green Macchia with Blue Etain Jimmies,*
1981, 8 × 9 × 9 inches

3 *Wisteria Violet Macchia with Plumbago Blue Lip
Wrap,* 1982, 6 × 12 × 8 inches

4 *Delta Yellow Macchia with Cassel Lip Wrap,* 1981,
10 × 10 × 10 inches

5 *Red and Green Dappled Daffodil Macchia with
Orion Blue Lip Wrap,* 1981, 6 × 7 × 6 inches

6 *Cadmium Yellow Macchia with Oxblood and Cobalt
Patterns,* 1982, 4 × 6 × 6 inches

7 *Alabaster Macchia with Multicolored Jimmies,* 1981,
6 × 5 × 5 inches

8 *Lumière Green Macchia with Lapis Blue Lip Wrap,*
1981, 5 × 5 × 5 inches

9 *Almond Pink Macchia with Aero and Oxblood
Jimmies,* 1982, 5 × 10 × 8 inches

10 *Aureolin Macchia with Pech Black Lip Wrap*, 1982,
 8 × 12 × 11 inches

11 *Abalone and Crimson Spotted Macchia*, 1982,
 7 × 9 × 9 inches

12 *Auburn Macchia with Phosphor Blue Lip Wrap*, 1981,
 6 × 7 × 7 inches

13 *Larkspur Blue Macchia with Persimmon Lip Wrap*,
 1981, 8 × 12 × 10 inches

14 *Thames Gray Macchia with Kingfisher Blue Lip
 Wrap*, 1982, 6 × 9 × 7 inches

15 *Roseleaf and Italian Ochre Macchia*, 1982,
 8 × 8 × 7 inches

16 *Concord and Aubergine Macchia with Variegated
 Jimmies*, 1981, 5 × 7 × 6 inches

17 *Chinese Yellow Macchia with Peach Stripes*, 1982,
 11 × 9 × 8 inches

18 *Vermilion Macchia with Black Charcoal Lip Wrap*,
 1982, 6 × 8 × 6 inches

28 *Pheasant Macchia Set with Eucalyptus Lip Wraps,* 1984, 9 × 26 × 19 inches

29 *Cobalt Turquoise Macchia Pair with Terra Rosa Lip Wraps,* 1983, 12 × 20 × 17 inches

30 *Marigold Macchia Set with Kashmir Green Lip Wraps,* 1986, 14 × 27 × 20 inches

Numbers 31 – 39 are part of the *Macchia Forest.*

31 *Tiger Lily Macchia with Naples Yellow Lip Wrap,* 1992, 17 × 29 × 29 inches

32 *Cerise Pink Macchia with Vermilion Lip Wrap,* 1992, 17 × 31 × 33 inches

33 *Citron Yellow Macchia with Mars Orange Lip Wrap,* 1992, 20 × 30 × 30 inches

34 *Malmaison Rose Macchia with Yellow Madder Lip Wrap,* 1992, 16 × 30 × 30 inches

35 *Lemon Yellow Macchia with Rose Lip Wrap,* 1992, 20 × 32 × 27 inches

36 *Argon Macchia with Chrome Yellow Lip Wrap,* 1992, 17 × 37 × 31 inches

\

37 *Magenta Macchia with Yellow Lip Wrap*, 1992, 37 × 21 × 31 inches

38 *Sapphire Macchia with Scarlet Lip Wrap*, 1992, 17 × 33 × 29 inches

39 *Chrome Yellow Macchia with Dauphine Lip Wrap*, 1992, 19 × 30 × 27 inches

40 *Macchia Drawing #14, 1982*, 30 × 22 inches Charcoal, watercolor, and graphite on paper

41 *Macchia Drawing #10, 1983*, 30 × 22 inches Mixed media on paper

42 *Macchia Drawing #7, 1983*, 30 × 22 inches Mixed media on paper

43 *Macchia Drawing #8, 1984*, 30 × 22 inches Mixed media on paper

44 *Macchia Drawing #27, 1986*, 30 × 22 inches Graphite and watercolor on paper

45 *Macchia Drawing #31, 1989*, 30 × 22 inches Graphite, charcoal, and watercolor on paper

46 *Macchia Drawing #14, 1989,* 22 × 30 inches
Graphite, charcoal, and watercolor on paper

47 *Macchia Drawing #9, 1989,* 30 × 22 inches
Mixed media on paper

48 *Macchia Drawing #18, 1991,* 41 × 29 inches
Acrylic on paper

49 *Macchia Drawing #12, 1991,* 41 × 29 inches
Acrylic on paper

50 *Macchia Drawing #10, 1991,* 41 × 29 inches
Acrylic on paper

51 *Macchia Drawing #14, 1992,* 60 × 40 inches
Acrylic on paper

52 *Macchia Drawing #17, 1992,* 60 × 40 inches
Acrylic on paper

53 *Macchia Drawing #29, 1992,* 41 × 29 inches
Acrylic on paper

54 *Macchia Drawing #9, 1993,* 60 × 40 inches
Acrylic on paper

1941 Born September 20, Tacoma, Washington, to Viola and George Chihuly, a union organizer.

1959 Enrolls in University of Puget Sound, Tacoma.

1960 Transfers to University of Washington, Seattle.

1961-62 Learns to melt and fuse glass in his basement studio in south Seattle.

1962-63 Travels to Europe and Near East. In Israel works on a kibbutz.

1963 Re-enters University of Washington, studying interior design and architecture under Hope Foote and Warren Hill. In weaving classes with Doris Brockway begins incorporating glass into tapestries.

1964 Returns to Europe. Receives Seattle Weavers Guild Award.

1965 Meets textile designer Jack Lenor Larsen. Receives BA in interior design, University of Washington. Works as a designer for John Graham Architects, Seattle. Experimenting on his own, blows glass for the first time.

1966 Works as commercial fisherman in Alaska to earn money for graduate studies in glass. Enters University of Wisconsin, Madison, to study glass blowing with Harvey Littleton.

1967 Receives Master of Science from University of Wisconsin. Enrolls in Master of Fine Arts program at Rhode Island School of Design (RISD). Meets Italo Scanga.

1968 Receives Master of Fine Arts from RISD. Awarded Tiffany Foundation Grant and Fulbright Fellowship to study glass in Venice, the first American glass blower to work there.

1969 Visits Erwin Eisch in Germany as well as Jaroslava Brychtová and Stanislav Libenský in Czechoslovakia. Returns to RISD to establish glass department.

1970 Meets James Carpenter at RISD and begins four-year collaboration.

1971 Has solo exhibition with Carpenter at the Museum of Contemporary Crafts (now American Craft Museum), New York. With a grant from the Union

of Independent Colleges of Art, starts Pilchuck Glass School in Washington on property donated by arts patrons John Hauberg and Anne Gould Hauberg.

1972-73 Works on glass architectural projects with Carpenter.

1974 Experiments with new "glass drawing pick-up techniques" at Pilchuck.

1975 Receives first of two National Endowment for the Arts Grants. Develops "Navajo Blanket Cylinder" series.

1976 Collaborates with Seaver Leslie on "Irish" and "Ulysses Cylinders," with Flora Mace fabricating glass drawings. Travels with Leslie to Great Britain on lecture tour. Loses sight in left eye in automobile accident.

1977 Becomes head of RISD sculpture department. Begins "Basket" series at Pilchuck inspired by seeing Northwest Coast Indian baskets at Washington State Historical Society, Tacoma.

1978 Exhibition "Baskets and Cylinders: Recent Work by Dale Chihuly" shown at the Renwick Gallery, Smithsonian Institution, Washington, DC. Meets William Morris, beginning an eight-year working relationship.

1979 Relinquishes gaffer position when shoulder becomes dislocated in body surfing accident.

1980 Becomes artist-in-residence at RISD. Begins "Sea Forms" series.

1981 Begins "*Macchia*" series.

1982 "Chihuly Glass" opens at Tacoma Art Museum and travels through 1984 to five American museums.

1983 Sells Boathouse studio in Rhode Island. Moves to Seattle to live and work.

1984 Honored as RISD's President's Fellow. Receives Visual Artist's Award from American Council for the Arts and first of three Washington State Governor's Art Awards. Begins "Soft Cylinders" series. "Chihuly: A Decade of Glass" opens at the Bellevue Art Museum, Washington, and travels.

1985 Experiments with "Flower Forms." Renovates
 Buffalo Shoe Building as studio in Seattle.

1986 Named Fellow of the American Craft Council.
 Receives honorary doctorates from the University
 of Puget Sound and RISD as well as Governor's Art
 Award from Rhode Island. Begins "Persians" series
 working with gaffer Martin Blank. "Dale Chihuly:
 Objets de Verre," organized by the Musée des Arts
 Décoratifs, Palais du Louvre, Paris, opens and
 travels in Europe and the Middle East through
 1991. Kodansha International Ltd. publishes
 Chihuly: Color, Glass and Form.

1987 Completes *Rainbow Flower Frieze* installation at
 Rockefeller Center, New York. Builds first glass
 blowing studio in Seattle at the Van de Kamp
 Building. Honored as University of Washington
 Alumni Legend. "Chihuly Collection" installed at
 the Tacoma Art Museum.

1988 In Seattle begins "Venetians" series with maestro
 Lino Tagliapietra. Receives honorary doctorate
 from California College of Arts and Crafts.

1989 Twin Palms publishes *Venetians: Dale Chihuly.*
 Special individual exhibition at Bienal de São Paulo
 travels to Santiago, Chile. At Pilchuck works with
 Italian maestro Pino Signoretto experimenting with
 additions of putti to "Venetians." With Tagliapietra
 adds flower forms to "Venetians" for the "Ikebana"
 series.

1990 Survey exhibition, "Dale Chihuly: Japan 1990,"
 presented by Azabu Museum of Arts and Crafts,
 Tokyo. Renovates Seattle Pocock racing shell factory
 on Lake Union into new Boathouse,
 incorporating glass blowing shop, studio, and
 residence.

1991 Exhibition "Chihuly: Venetians," organized by the
 Uměleckǒprumyslové Muzeum, Prague, travels in
 Europe. Completes major private and public
 architectural installations. Begins to experiment
 with "Niijima Floats" series working with gaffer
 Richard Royal.

1992 Exhibits "Niijima Floats" at the American Craft
 Museum. Creates major new architectural
 installations for the Seattle Art Museum's "Dale
 Chihuly: Installations 1964-1992," which travels.

Recreates *20,000 Pounds of Ice* (1971) temporary installation for this show. Development of chandeliers begins with the *SAM Chandelier*. Commissioned for large-scale architectural installations at Little Caesars Corporate Headquarters in Detroit and Corning Glass Headquarters in Corning, New York. Develops stage sets for 1993 Seattle Opera production of Debussy's *Pelléas et Mélisande*, experimenting with new materials. A new glass series, "Pilchuck Stumps," grows out of these designs. Receives first National Living Treasure Award given by the United States.

1993 "Chihuly: Form from Fire" begins tour of southern museums at the Lowe Art Museum, Miami, Florida. "Chihuly in Australia: Glass and Works on Paper" opens at the Powerhouse Museum, Sydney, and tours Australia. "Dale Chihuly Day" declared in Seattle. Seattle Opera premieres stage sets for *Pelléas et Mélisande*. "Chihuly alla *Macchia*" opens at the Art Museum of Southeast Texas, Beaumont. Named Alumnus Summa Laude Dignatus by the Alumni Association, University of Washington.

This catalog is for all the glass blowers and artists who have made my work possible. And for George Stroemple and Tracy Savage whose support has been immeasurable.

Dale Chihuly
The Boathouse
Seattle, Washington
July 16, 1993

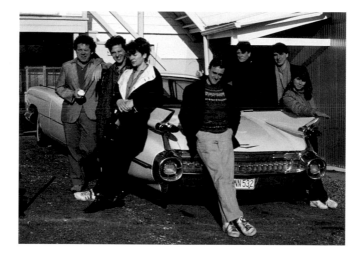

The East Coast *Macchia* Team, 1983
photograph by Kate Elliott

Colophon

All photographs of glass works by Terry Rishel,
unless otherwise noted
All photographs of drawings by Michael Seidl

Designed by Werkhaus Design, Seattle, WA
Color separations by Aurora Color, Washington, DC
Printed by Anderson Lithograph, Los Angeles, CA
Bound by Roswell Bindery, Phoenix, AZ

Glass works printed on Quintessence Gloss
Drawings printed on Mohawk Superfine

Typefaces are Gill Sans and Minion

Art Museum of Southeast Texas
500 Main Street
Beaumont, TX 77701
409-832-3432